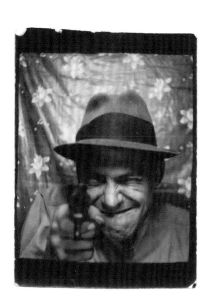

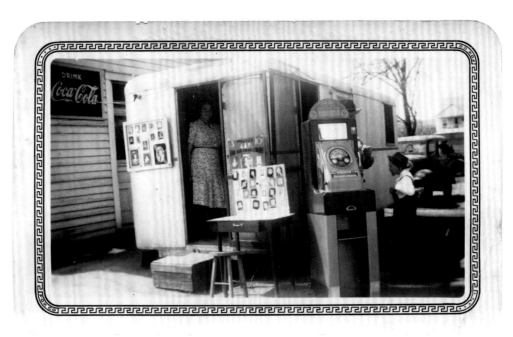

MAKING PICTURES

THREE FOR A DIME

The Massengill Photographs
Arkansas, 1934–1945

MAXINE PAYNE

DUST *to* **DIGITAL**

Special thanks: the Massengill Family,
especially Sondra Massengill McKelvey and
Kathy Massengill Duncan, Natalie Chanin and
John T. Edge.

First edition 2014

Co-published by Dust-to-Digital and Institute 193

All photographs © Maxine Payne

Design: Debbie Berne Design

Institute 193
193 North Limestone Street
Lexington, KY 40507
www.institute193.org

DUST ᴛᴏ DIGITAL

PO Box 54743
Atlanta, GA 30308
www.dust-digital.com

ISBN 978-0-9817342-5-5
Printed in China

Also available on Dust-to-Digital: *Corn Dodgers and
Hoss Hair Pullers: Arkansas at 78 RPM*, an audio release
inspired by the photographs exhibited in this book, with
liner notes by country music scholar, Tony Russell.

Fashion designs inspired by photographs from this book
are available from www.alabamachanin.com.

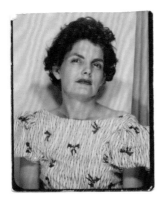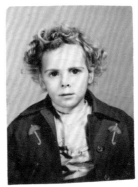

To my grandma, Alice Viola Nelson Thomason,
and my mom, Jackie Montaine Bowman Payne

MASSENGILL FAMILY TREE

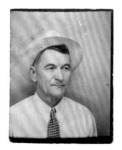

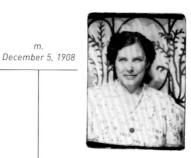

m.
December 5, 1908

James Preston Massengill
b. March 13, 1882

Mancy Creech
b. October 4, 1890

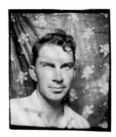

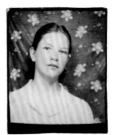

Lance Warren Massengill
b. April 4, 1913

Mary Evelyn Ritter
b. May 29, 1923

Preston Warren Massengill
b. March 8, 1939

Twila Sondra Massengill
b. December 21, 1941

Glenda Gail Massengill
b. September 7, 1944

Cecil Norman Massengill
b. October 26, 1957

"We didn't have much money at all and times were hard, but we were young and it didn't seem to bother us much. I guess it just seemed like a big adventure."

—EVELYN MASSENGILL

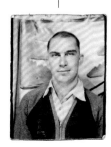

Duard W. Kerlen
b. June 4, 1910

Lawrence Henry
Massengill
b. January 15, 1916

Thelma Alice Bullard
b. October 1, 1919

Thena Mildred
Massengill
b. February 23 1919

Larry Wayne Massengill
b. May 16, 1940

Jimmie Edgar Massengill
b. December 6, 1948

Kathryn LaNell Massengill
b. July 20, 1957

Victor Rowlan Kerlen
b. March 30, 1937

Garland Wade Kerlen
b. March 12, 1939

Beverly Kay Kerlen
b. September 18, 1941

LIFE TURNS ON A DIME

One Saturday morning in the mid-1930s, Mancy Massengill, a wife and mother of three, saw people having their pictures made in a dime store photo booth in Batesville, Arkansas. According to her son Lance, "she watched close, and got the name off the camera, then wrote to the company and ordered the lens. She got the money for that by taking about two-dozen pullets in for sale." Her husband, Jim, built a box to house the lens and outfitted a trailer to create a mobile photography studio. On weekends, they would set up in little towns across the state and make pictures, three for a dime.

Jim and Mancy Massengill started this family business to make ends meet. Work was scarce in rural Arkansas where a farm-based economy had been devastated by the drought of 1930; a severe drop of the price of cotton; and the Great Depression. The Massengills understood that even in rough times, life continues: babies are born, children play, couples meet, and we all grow older. Someone needed to be there to capture those moments and that person could perhaps make a living doing it.

A few years later, the Massengill's sons, Lance and Lawrence, and their wives, Evelyn and Thelma, worked their way into the business. They outfitted trailers and made pictures, traveling across the state in search of clients. The surviving family diaries and notes from this period attest to a strong and entrepreneurial work ethic, with little mention of aesthetics or technique. With few exceptions, the stories are left to be told by the pictures they made.

The Massengill family photographs can be playful, serious, strange, and at times, haunting. Created as precious souvenirs, these photographs recorded moments experienced by the young, old, and everyone in between. Viewed today, the images offer an intimate portrait of the rural South of a bygone era. All the photographs collected in this book were created by members of the Massengill's extended family in the 1930s and 40s, but the individual photographers remain, for the most part, unknown.

It is the essence of literature, film, art, and music—life turns on a dime. Mancy Massengill walks into a store and has an idea to start making photographs. Almost seventy years later, Maxine Payne, a photographer from Arkansas, reconnects with a family friend, Sondra Massengill McKelvey, the daughter of Lance and Evelyn, and is invited to discover hundreds of photographs that she never knew existed. Those two events, not excluding everything that happened in between, have brought this project into being. Today, thanks to luck or providence, or both, we have been afforded the opportunity to see these photographs that would have otherwise been lost to the slow but inevitable passage of time.

—*Phillip March Jones*

MAKING PICTURES

Having been raised in rural Arkansas by my grandparents gave me many advantages in life. One was understanding the value of visiting people and having true friends. One of my favorite places to visit on Saturday nights was Uncle Lance and Aunt Evelyn's home. I liked it because Uncle Lance had built it, and it was one of the prettiest homes I had ever seen. It had an "upstairs" and, even though it was only one tiny room, it was the first "upstairs" I had ever encountered. It was quiet and peaceful, and it felt very safe. My memories of Uncle Lance and Aunt Evelyn are similar. They were quiet and peaceful people who my grandparents adored.

My grandpa, Norman Judd Thomason, met Lance around 1945 at the Zenith Seed Mill in Tuckerman, Arkansas, where they both worked. Later when Lance bought an old cotton farm, my grandpa moved his family to the adjoining farm and they helped each other build the homes they lived in. Years later when work in the South was too hard to find, the families would travel to Chicago for construction work, moving their families with them. Uncle Lance taught my grandpa, who otherwise couldn't read or write, how to read blueprints and this was how my grandpa would make a living for the rest of his life, in construction. Our families were always close, they took care of each other in very hard times, and Norman and Lance were lifelong friends.

In 2003, my grandpa and grandma passed away within months of each other, and Sondra Massengill McKelvey attended both of their funerals, bringing her mother, Aunt Evelyn. Sondra said she had

photographs of my mother and grandparents that she wanted to share with me when I saw her at my grandpa's funeral. It was on one of those trips to see Sondra at her home in Clarksville, Arkansas, when I first saw the Massengill family photographs.

This was a family of entrepreneurs and inventors. With no formal training they figured out how to build portable studios and homes, how to construct a camera, how to light and pose the subject, and how to make prints so that the client could purchase their image very quickly. They were able to get darkroom supplies in the 1930's in rural Arkansas, and perhaps the biggest feat, they maintained relationships and raised their children in these circumstances at a time that was very hard for everyone, even under normal living conditions.

The men built three portable photography studios on old truck frames. They hauled them behind cars that were only partly dependable, on roads that were less so. The women also went along. They helped with the business, they did the washing and the cooking, and they had the babies. This done in all seasons: hot Arkansas summers with no air-conditioning and cold winters with little or no heat (in Lawrence and Thelma's case, even on the day after their wedding!) They would find a town that they thought would present them with customers, seek out electricity, put up their advertisement, and begin their task: sleeping in their workplace, with pungent photo chemicals and no bathroom. From what I can gather, there were displays of photographs on a kind of

bulletin board outside the trailer, for folks to look at and get some idea of what they could purchase. The client would come into the trailer and sit down on a stool that had a backdrop behind it and two bright lights, just a few feet from the subject, which was also the room that housed the darkroom. The person working the camera took three shots and the positive paper was cut and processed immediately; much like the photo booth technology that was popular at that time. Most likely they were using a super speed direct positive paper, which would have eliminated the need for negatives (none have been found) and which allowed for a fast drying time. This would also account for the fact that the images are consistently backwards. If the client wanted their image to be hand tinted, they had to return the next day to pick them up and they were charged an extra nickel. Both the women and the men worked the camera and did the processing, but the women hand tinted the photographs, and they did it with tenderness and attention to detail. There were also enlargements made. These were shot from the small images and printed on the same type of paper.

It is easy to imagine that many more photographs were made. Most of the images we have now are of this family, made for love and not money. Many pictures were sold, but those of clients who didn't purchase them were probably thrown away, and many may have been lost through the years.

—*Maxine Payne*

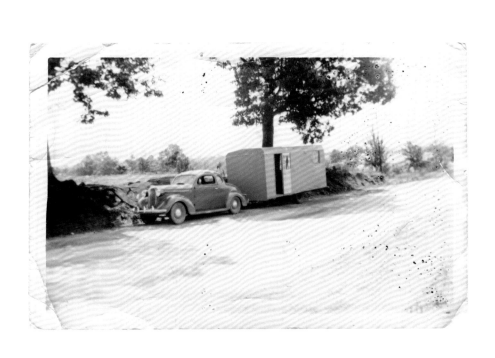

PLATES

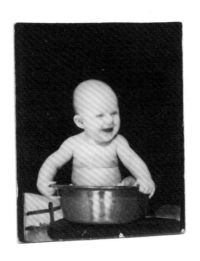

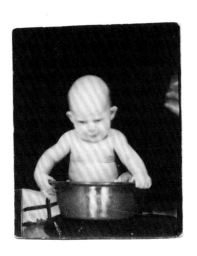

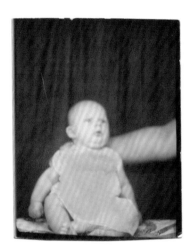

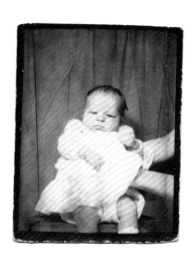

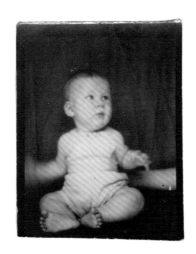

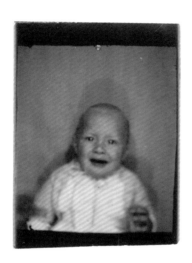

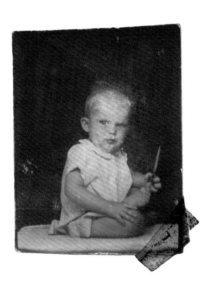

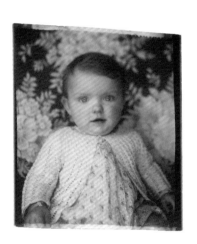

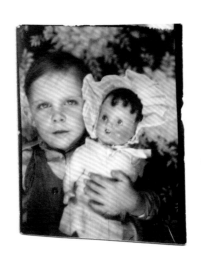

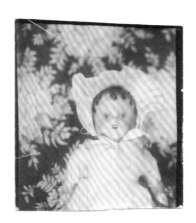

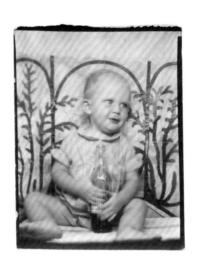

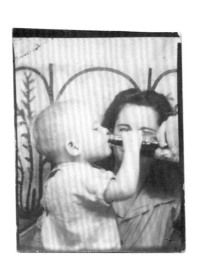

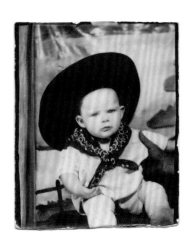

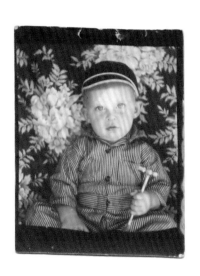

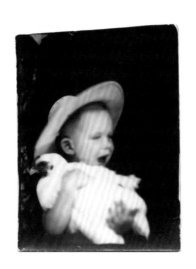

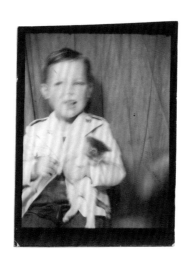

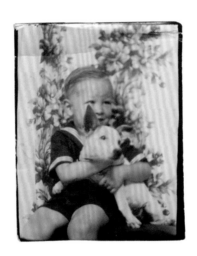

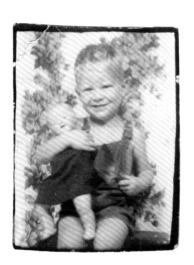

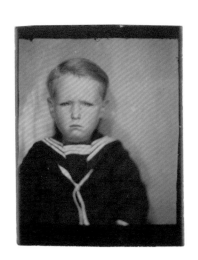

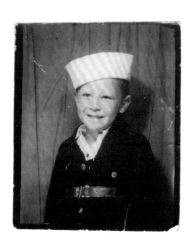

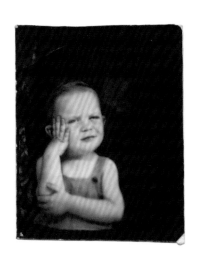

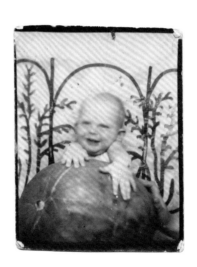

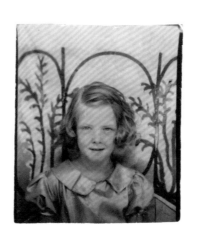

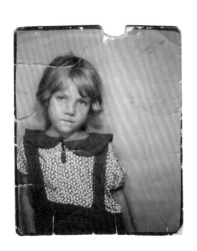

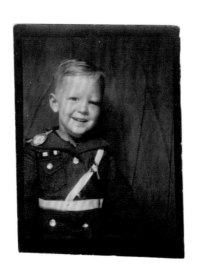

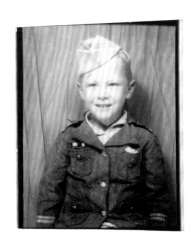

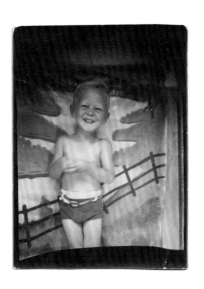

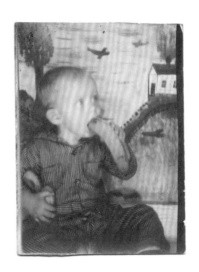

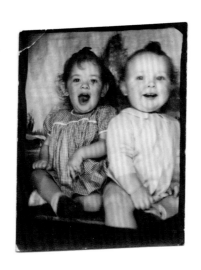

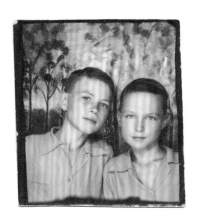

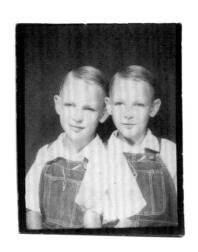

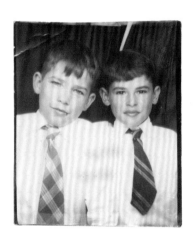

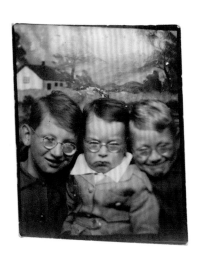

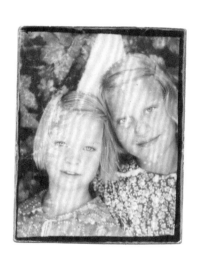

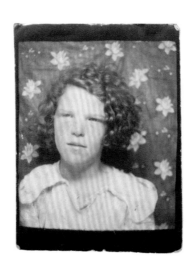

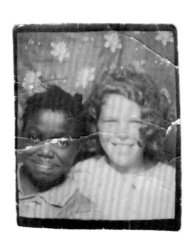

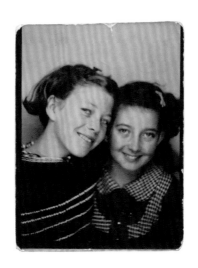

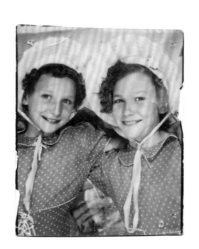

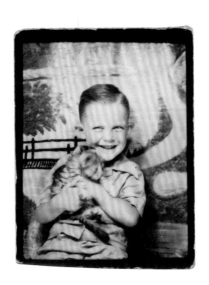

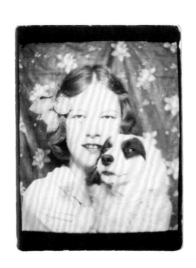

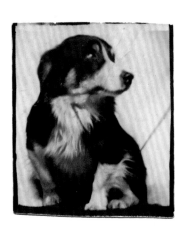

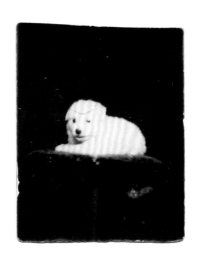

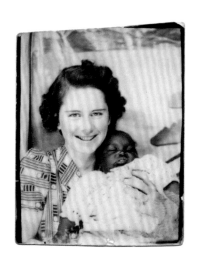

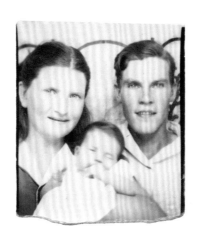

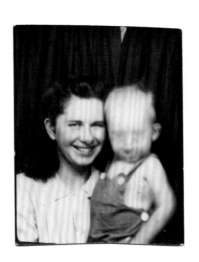

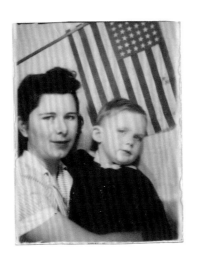

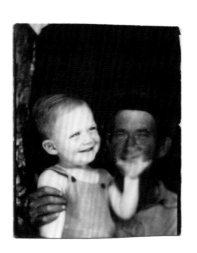

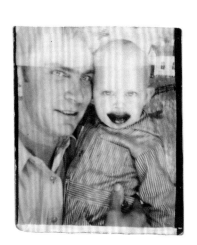

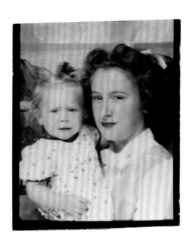

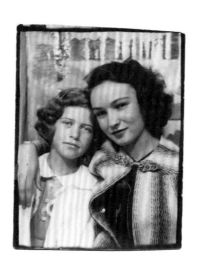

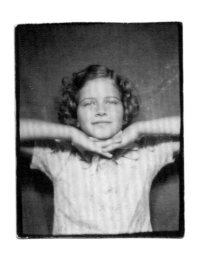

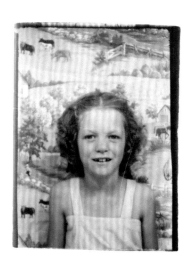

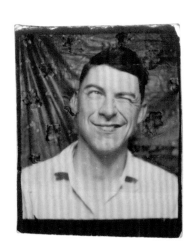

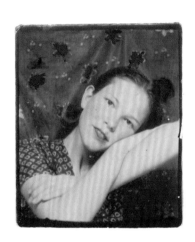

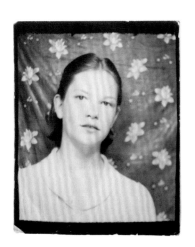

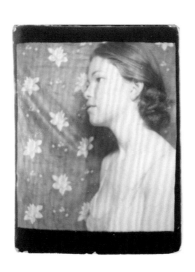

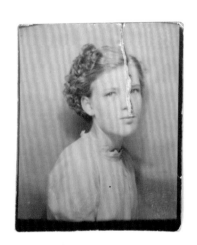

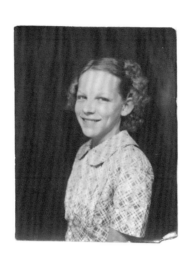

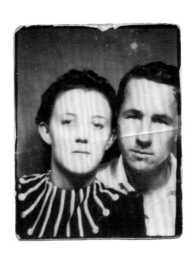

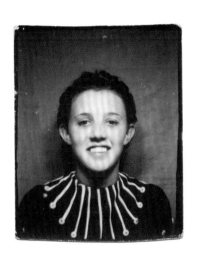

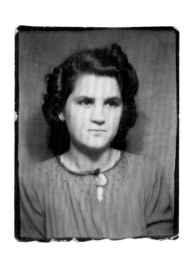

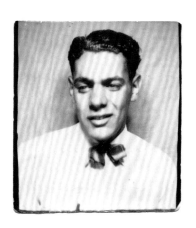

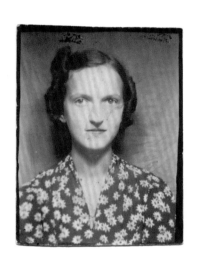

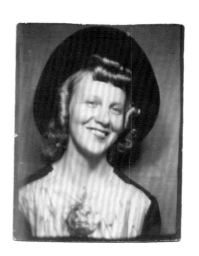

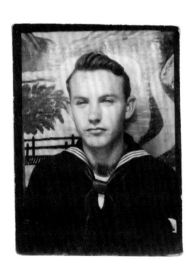

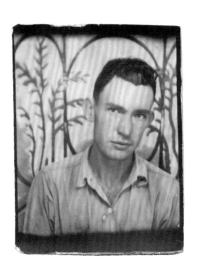

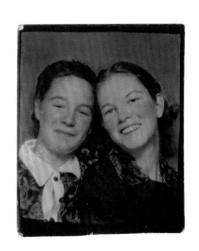

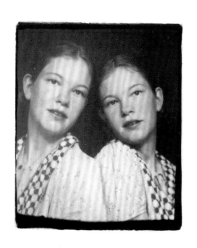

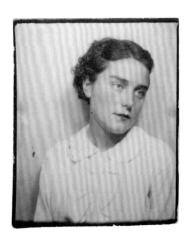

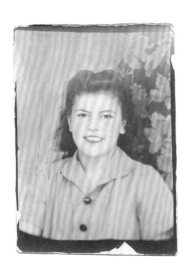

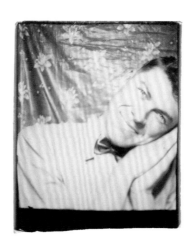

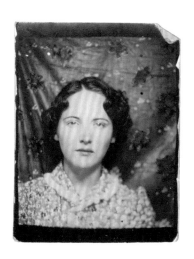

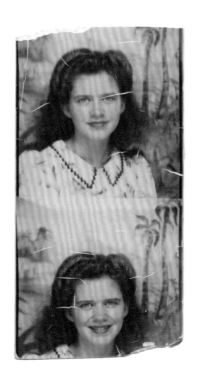

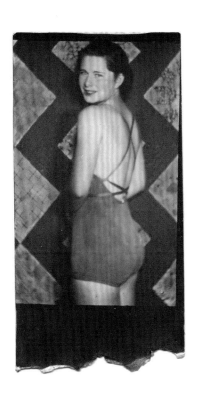

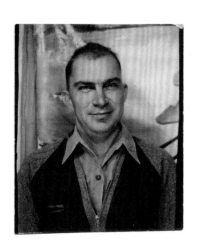

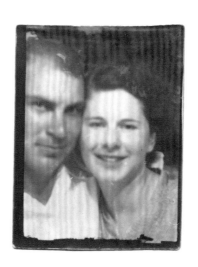

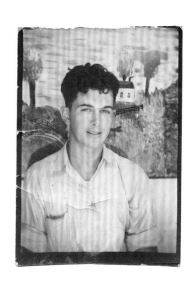

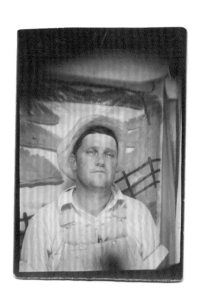

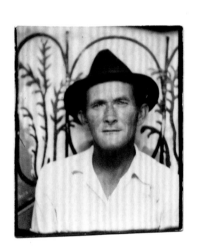

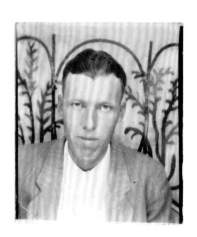

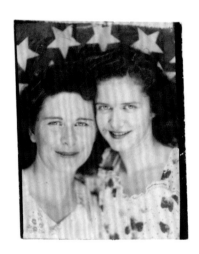

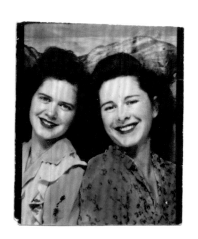

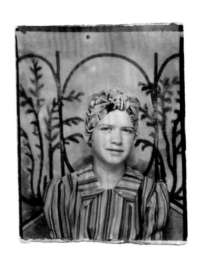

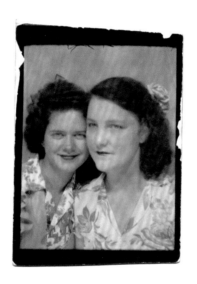

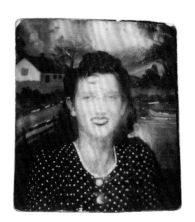

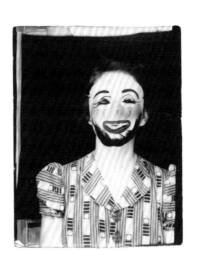

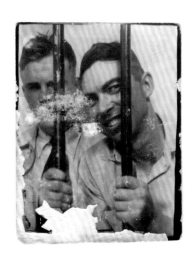

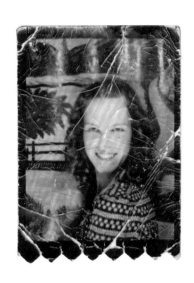

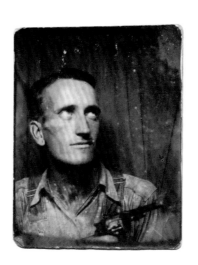

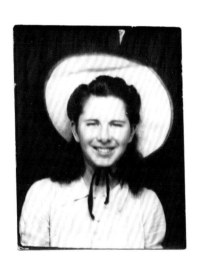

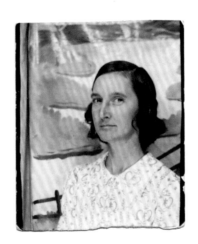

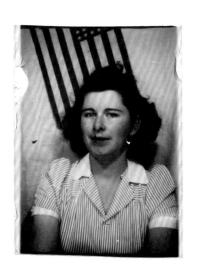

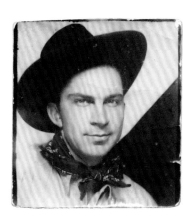

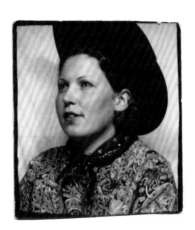

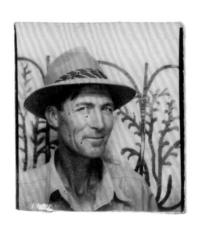

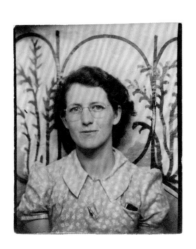

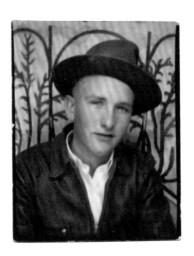

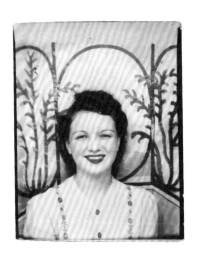

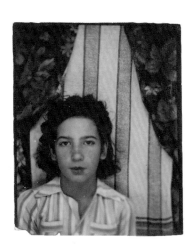

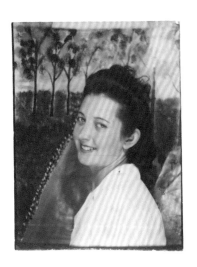

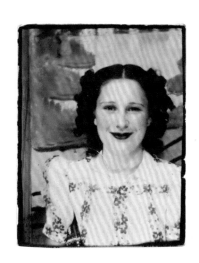

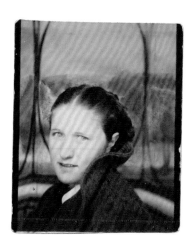

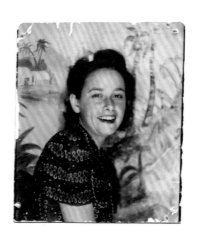

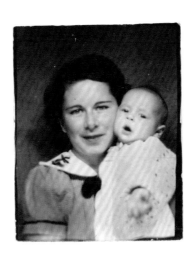

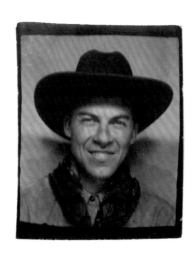

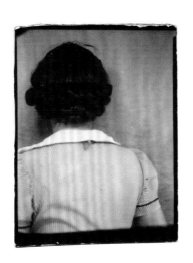

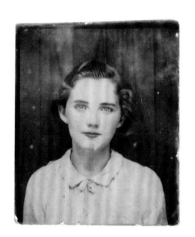

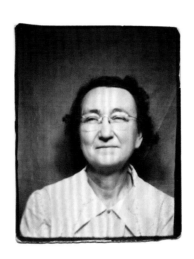

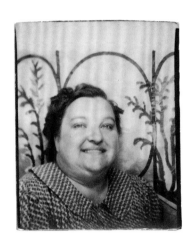

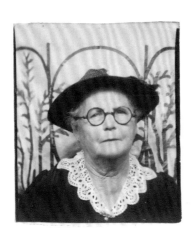

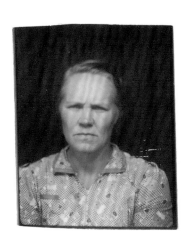

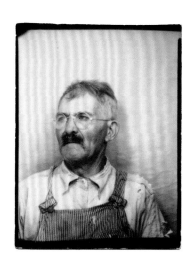

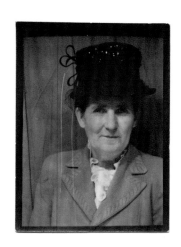

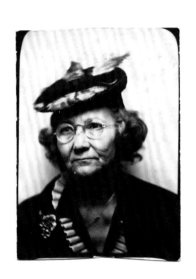

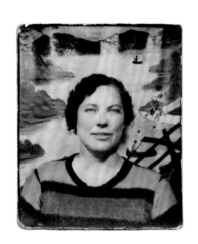

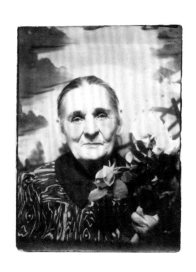

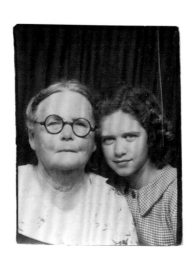

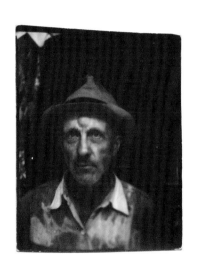

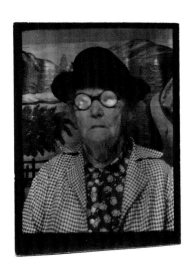

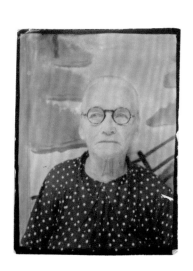

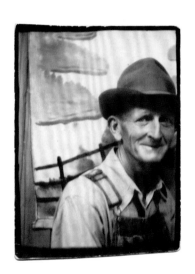

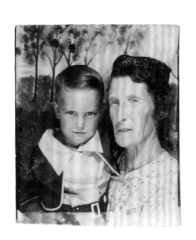

ALBUMS

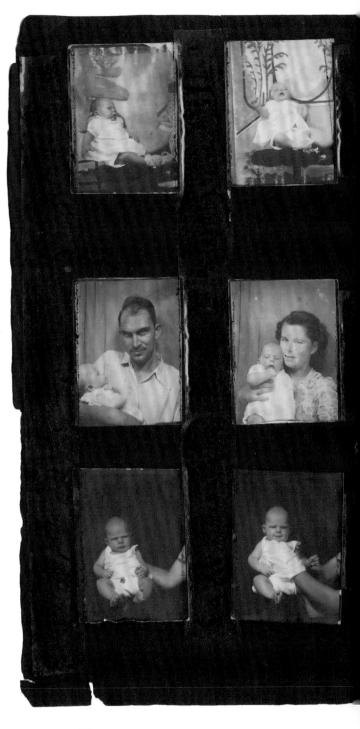

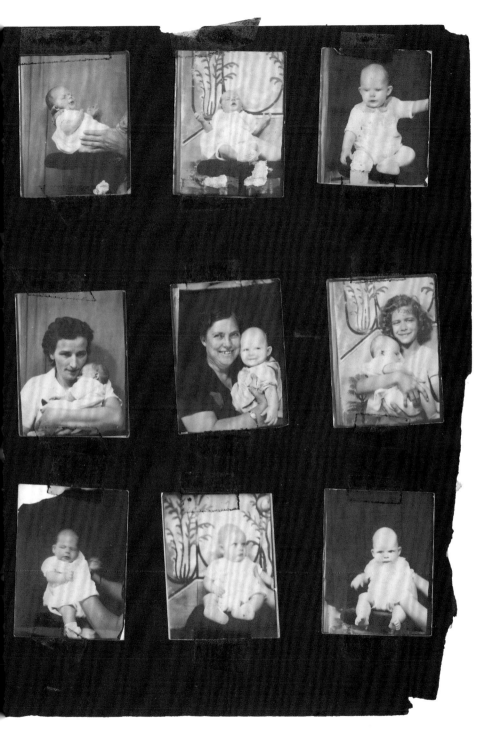

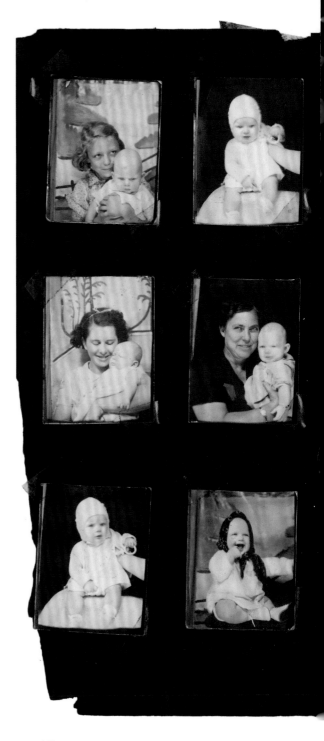

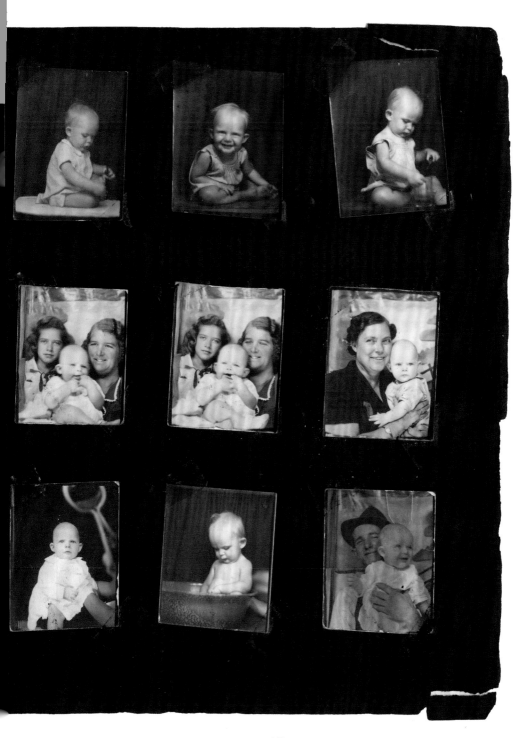

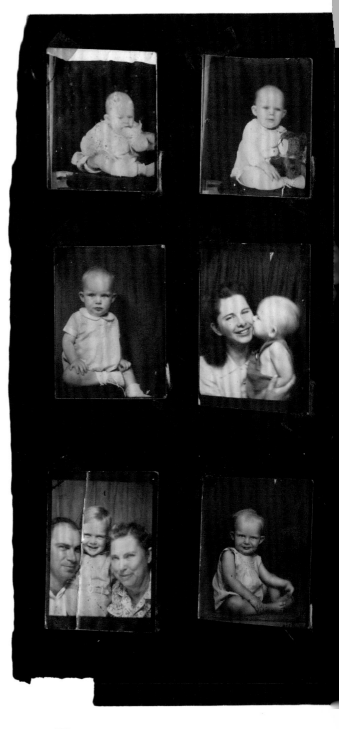

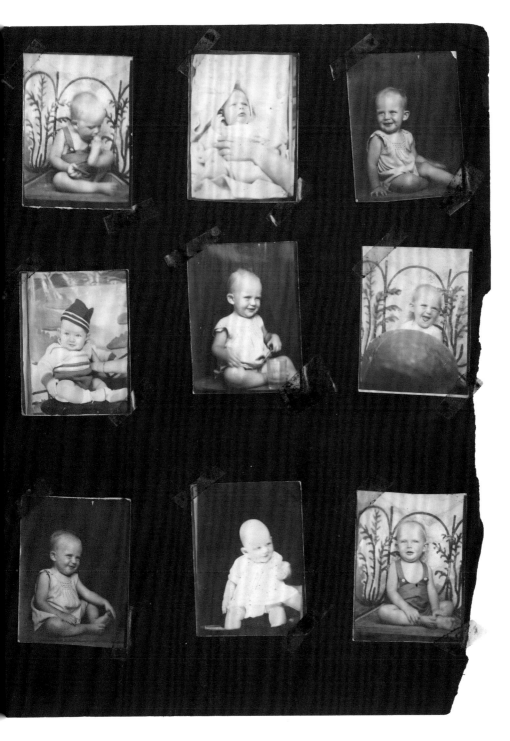

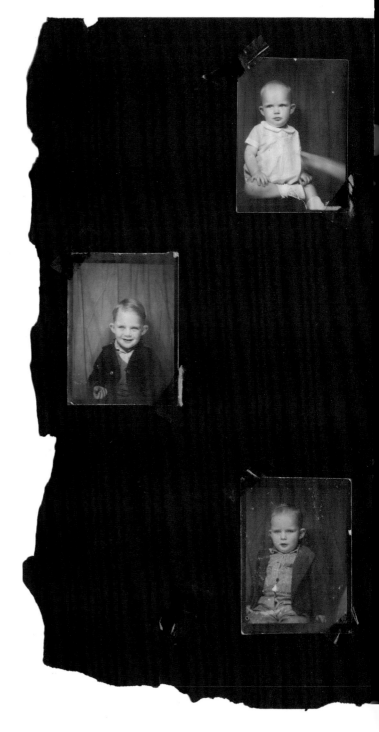

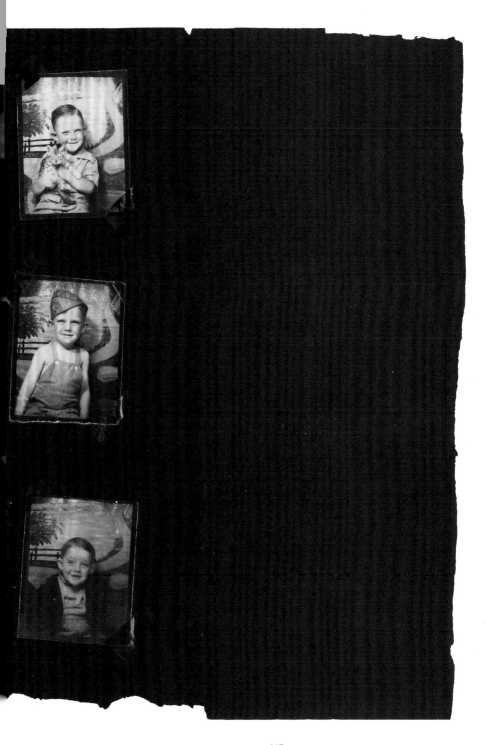

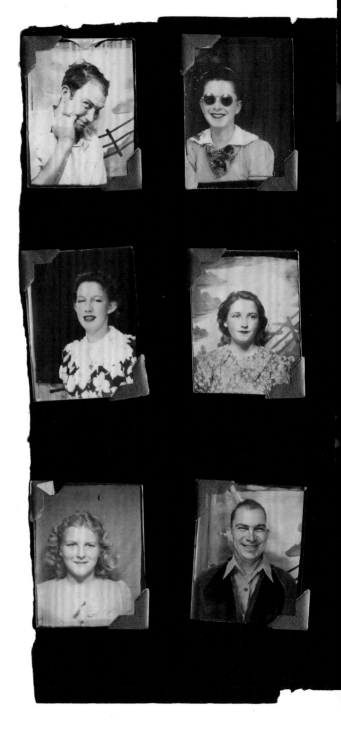

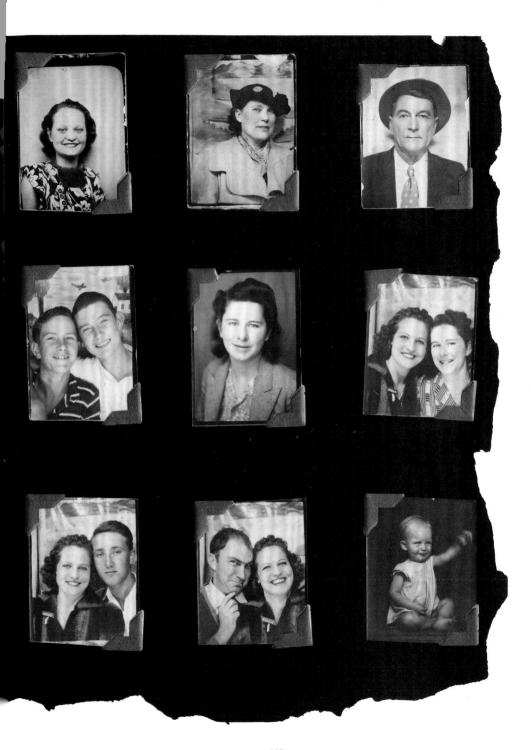

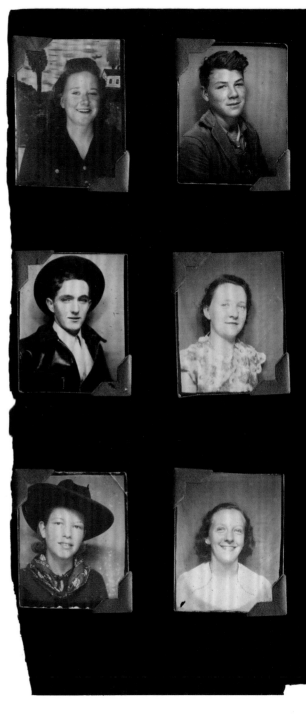

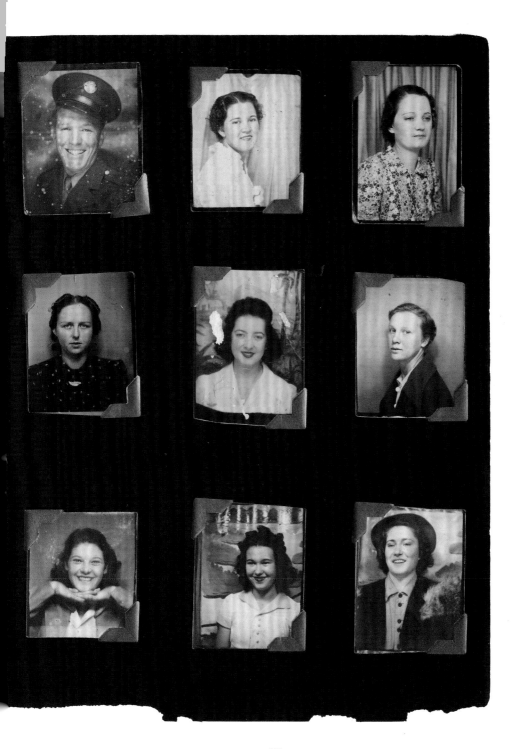

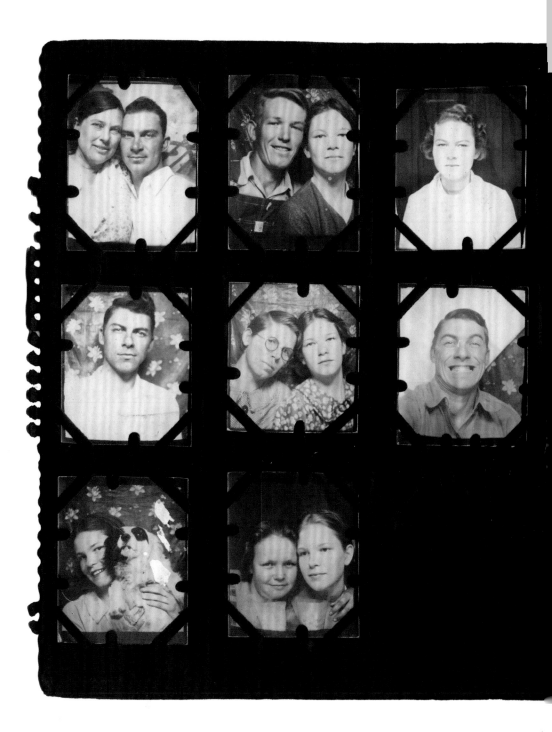

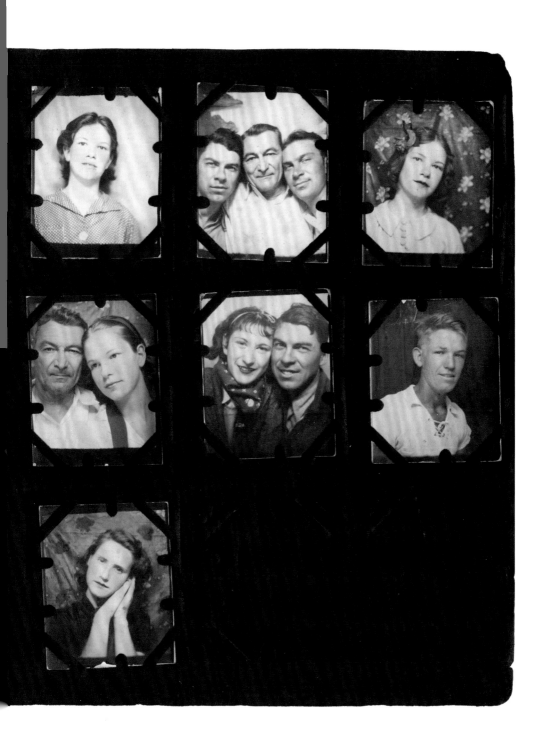

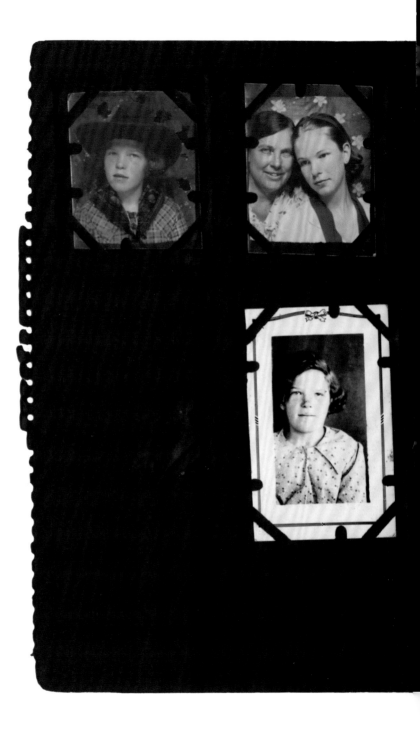

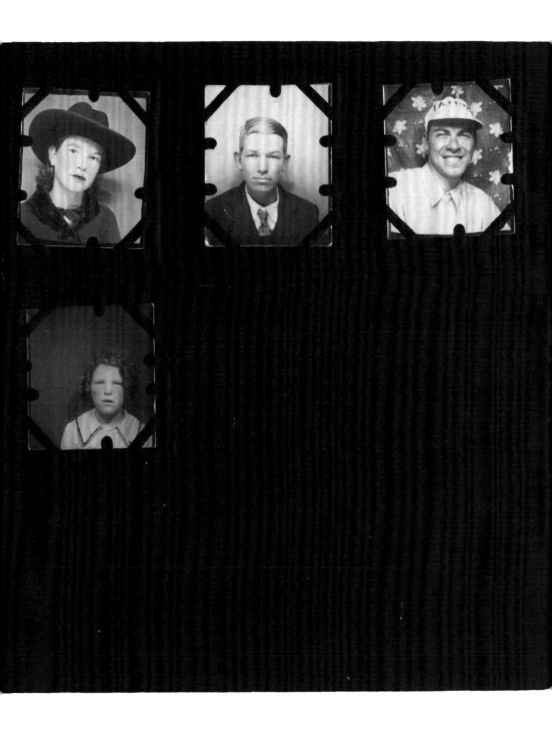

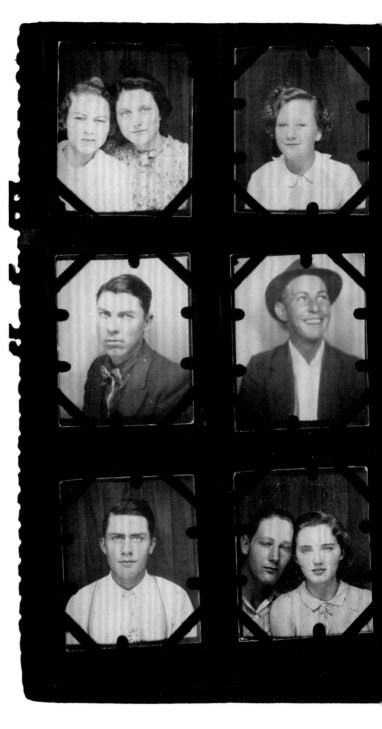

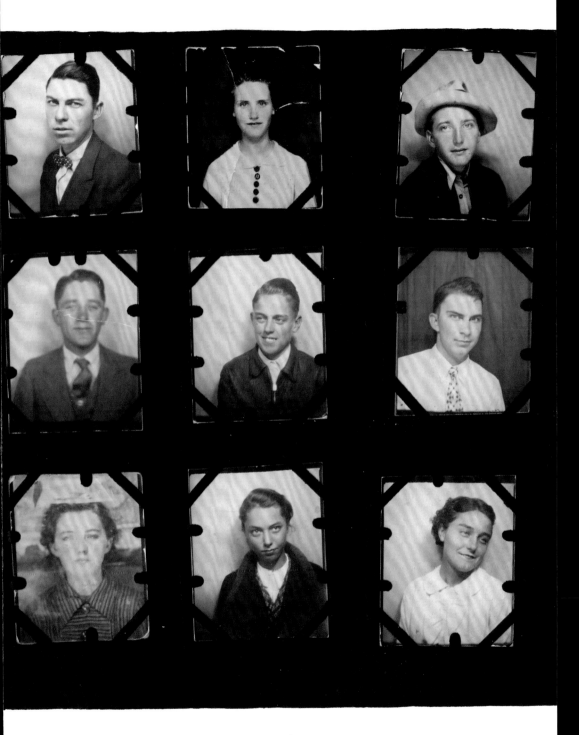

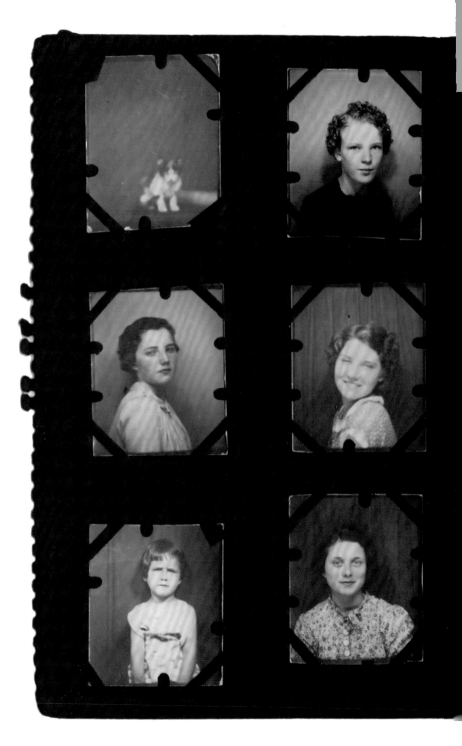

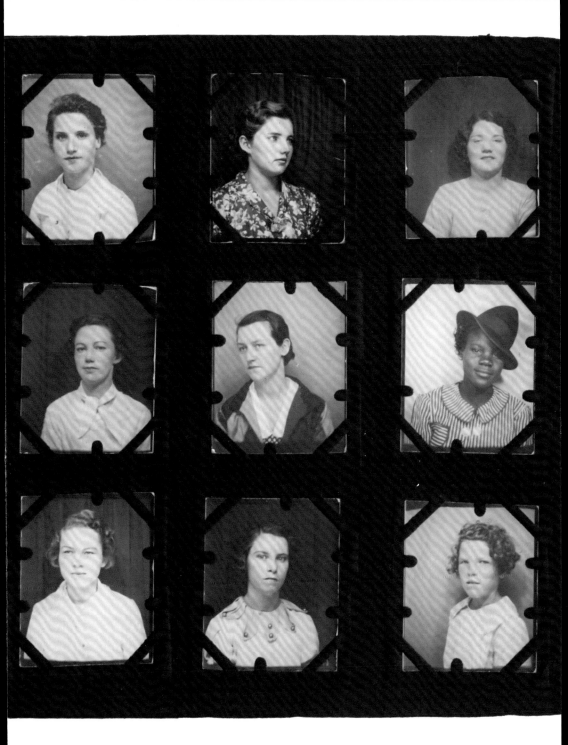

My folks (Jim and Mancy Massengill) left North Carolina in the 1920's, pretty sudden-like. It was never very clear why they left, but it was something about a knife fight Dad got into with another man. Anyway, they lived in Tennessee for a while, then up on the Spring River near Hardy, Arkansas before moving to Independence County, up on Brock Mountain.

They were farming there; nobody had any money at that time. Mother was pretty resourceful; she raised chickens and would take them in to town (Batesville) on weekends to sell. One Saturday she was in the dime store and saw people having their pictures made at a little booth there. She watched close, and got the name off the camera, then wrote to the company and ordered the lens. She got the money for that by taking about two-dozen pullets in for sale.

Dad built the box for the camera. They put it in the end of a little trailer Dad had built, and they would pull it around to towns around the area on weekends. Folks would come in to town on Saturday night, and they would make their pictures, 3 for a dime. They did that off and on for several years, to help make ends meet.

I was courting Evelyn Ritter and needed enough money to marry, so I went out to North Carolina; my brother-in-law worked there and wrote that I could find work. Dad and Mother had a lot of folks, Massengills and Creechs, in North Carolina. They were from Four Oaks and Johnston County. So we would visit them, and go around makin' pictures for a while. And I could always find some work to do there. I worked as a steelworker for a while, than came back for Evelyn. We married March 9, 1938; she was just 15 and the prettiest girl around; my brother Lawrence was courting her too, so I came back just in time.

I bought the picture-making trailer from Dad and we went back to Durham. I worked at steel work where I could, and we made pictures some. I brought Evelyn back home before Warren was born (March 8, 1939). We farmed there for a while but things were rough and we went back to North Carolina; we had family there around Four Oaks and Cherry Point.

I had a fall off an I-beam and broke my ankle; I made a steel brace that fit over my boot so I could work. I registered for the draft but it hadn't healed enough so they wouldn't take me. Later, after the war started I went back to enlist but they said they weren't taking men my age with children. Sondra was born in Raleigh on December 21, 1941, and I was 28 then. So that next summer we went back to Arkansas, making pictures and getting work where I could.

The picture-making was interesting; we worked at it mostly on Saturday because that was the only time anybody had money to spare. They came into town from farming or picking cotton or tobacco, when they got paid.

We ordered what supplies we needed, film and chemicals. Lance would make the pictures, and I learned to hand tint them. We charged extra for that, I think a dime. We had a signboard we would put on the front of the trailer, with prices and it had a frame to show off pictures; we would put the extra ones out, to advertise. One time a man came in and asked if he could buy his picture out of the frame. He was real worried; Lance said it was because it was a picture of him and a girl who was not his wife. So Lance gave him all the pictures.

We would pull into a little town on Friday night usually. Lance would find a good spot to park and would pay someone to let him plug in the electricity, for lights.

We didn't have much money at all and times were hard, but we were young and it didn't seem to bother us much. I guess it just seemed like a big adventure. After Sondra was born, though, living in the trailer was pretty rough for us. I wanted to go back home then, especially after the war started and Lance was trying to enlist.

So we moved back to Arkansas in July 1942. Mr. and Mrs. Massengill were living in Newport then and we lived there until we got enough money together to buy a farm near Tuckerman. Lance's folks still made some pictures with the trailer for a while, but we didn't use it anymore after that. We had some good memories of those times, hard as they were, and at least we have lots of pictures of our families and our babies, probably more than most people have from that time.

THELMA BULLARD MASSENGILL AND LAWRENCE MASSENGILL

DIARY ENTRIES (1939–1941)

The text in italics was written by Lawrence.

Jan. 1, 1939 Our first day of married life! We spent the day with Mother + Dad Massengill, and they chivereed us tonight.

Jan. 2, 1939 We moved to Heber Springs and started making pictures in the house trayler .5 cents

Jan. 3, 1939 *Teaching Thelma how to snap + develop pictures. We fixed the wire initial display. We took in $3.35*

Jan. 4, 1939 Uncle Lee and Aunt Annie came to visit us $1.30 before breakfast. Ruth + Amy came after school and brought us a (wedding) present.

Jan. 5, 1939 Our bigest day of picture making so far. I developed my first pictures to sell + tinted my first. Poor Lawrence has the ear ache. $3.45

Jan. 6, 1939 *Just another day come and gone. Thelma made several pictures and I made 1 enlargement It all amounted to $3.15.*

Jan. 7, 1939 Munk came at noon to stay 'till Monday. We got acquainted with Albert Best. This is our biggest day of picture making so far. we took in $11.30

Jan. 8, 1939 *Albert, Munk, Thelma And I started to Sugar loaf and got stuck Well just one of them thing, $7.10*

Jan. 9, 1939 We started home and old blue played out on us. Lawrence traded cars then we went home after supper. 95 cents

Jan. 10, 1939 *I got the brakes ajusted on the car and fixed a trailer hitch on it. Thelma done almost all the developing $2.90*

Jan. 11, 1939 Just another day at Heber Springs. We made $2.55. Mother and Dad came.

Jan. 12, 1939 Another rainy day! Ab and Henry came a while after supper. We just took in 55 cents.

Jan. 13, 1939 I washed today and Lawrence worked on the car horn. We took in $3.45.

Jan. 14, 1939 Another busy day at Heber Springs. Mother and dad Massengill and pappy Roy and Maxine came. We made more than usual $14.80 we went home at midnight.

Jan. 15, 1939 We stayed at home until 10:40 and brought back a load of wood. we made $4.25

Jan. 16, 1939 We stayed at Heber until 3:00 o'clock then went home to wash. Lawrence went home while I washed then we went to a party and spent the night at Ritters 50 cents today

Jan. 17, 1939 We had to stay home until our clothes got dry. I ironed them and we left just after dinner to come back to the little trailer house. 90 cents today

Jan. 18, 1939 Lawrence has been doing a little carpender work today. Jewell, Mildred and Ruth came. I backed against the stove and burned my leg ($2.70 today)

Jan. 19, 1939 At last! Our worries are over. Lawrence bought his first kotex. We took in $5.25 Lawrence, Munk and I went to the show.

Jan. 20, 1939 Ab and Munk came and Ab stayed for supper. Munk came back after supper $5.25

Jan. 21, 1939 Uncle Lee came to see us Sat morning also Eugene, Leonard and Mr. Teter, we took in $19.00 Ab, Munk, Lawrence and I cooked supper at 12:00 p.m.

Jan 22, 1939 We stayed in bed until 10:00 o'clock. We went to camp Heber before breakfast. Ruth came this afternoon and stayed until church time. $4.85

Jan. 23, 1939 What a dad day! It rained and froze all day. We went home. Lawrence went to Heber before breakfast. Ruth came this afternoon and stayed until church time $4.85

Jan. 24, 1939 Today was as beautiful as yesterday was bad. We came back to Heber about 10:00 o'clock. Munk and Mr. Hall came with us. $2.20 Lawrence enlarged mine and Lynn's baby picture.

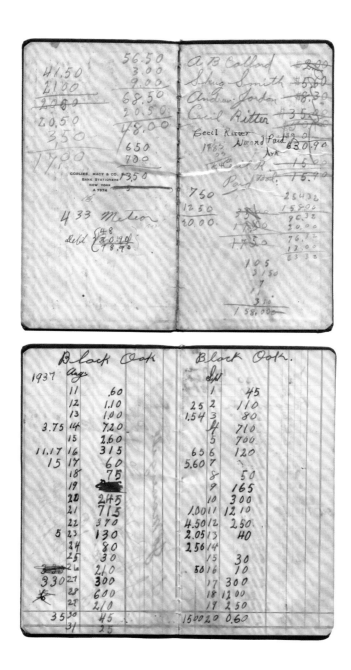

Pages from Lance Massengill's logbook

Jan. 25, 1939 Lawrence made an enlargement of Mother Massengill Munk and I went window shoping. Lawrence bought him some new clothes.

Jan. 26, 1939 I went to Mrs. Garretts to wash Lawrence fixed the car fenders. Ab, Munk and henry came. The hotel burned last night. $1.80.

Jan. 27, 1939 Mother and dad Massengill came today. We are both sick with a bad cold. Munk, Ruth, Henry and Ab came this afternoon.

March 4, 1939 It rained all day today. After we closed up we took Doc Verser and Dean Samples to Kirks on the way home we had a wreck.

March 5, 1939 I am sick with a cold today I guess I got too cold yesterday. L.H. is having to work by himself today.

March 6, 1939 Uncle lee came over to have his teeth pulled and Lawrence went to the Dr. with him. Ruth and I went strolling in the park.

March 7, 1939 They finished the car today. we went to the show. Munk came by telling about being fired at Woods.

March 8, 1939 *Spring must be here for Thelma washed her head. The sun shone migty worm. And I painted the car.*

March 26, 1940 We left Heber Springs today we had more friends here than we though we had. We are spending the night in Bald Knob.

March 27, 1939 We moved on to Russell today and had a time getting set down here. Such a lonesome place!

March 28, 1939 Mother and Dad came by going home and we went with them. I washed this afternoon then went to the school house to hear the Jewell Cowboys.

March 29, 1939 We came back to Russell today. Lawrence worked on the machine and I ironed some.

April 1, 1939 Our first Saturday at Russell we didn't make much today. I washed and Lawrence worked on the car horn.

April 2, 1939 We went to Mother's and Dads before breakfast then we went home. We took some kids to the river and pulled of our shoes and waded.

April 3, 1939 I washed this morning. Lawrence, Mother, Munk and I went fishing this afternoon. we caught seven fish.

April 4, 1939 We took Lance and Evelyn to Batesville this morning. Then we came back to Russell we stoped at Vergies as we came by.

April 5, 1939 We went to Mother's and Dads We went on to Golden's to dig some fish bait but it rained and we didn't go fishing.

April 6, 1939 We worked the darkroom over today. It turned real cold today.

April 7, 1939 It is freezing cold this morning. I'm afraid the berries will freeze. We went to the creek to hunt Lawrence's knife.

April 8, 1939 Dad came this morning. We didn't make very good today. Obrey and Galdys came after supper and stayed a while.

April 9, 1939 We went to Bald Knob this afternoon.

April 10, 1939 We took an old woman to Judsonia to the Doctor.

April 11, 1939 We went to Bald Knob before breakfast then went fishing. We didn't even get a bite. We went to the creek when we got home.

April 12, 1939 We took a lady to Searcy to have an exray made of her foot.

April 13, 1939 Lawrence went fishing and I spent a lonely day all alone.

April 14, 1939 Just another day at Russell. I went to Mrs. Byrds to get some eggs.

April 15, 1939 I washed my hair and Lola Mae fixed it Lawrence put some wave set on his hair to see if it would lay down.

April 16, 1939 Rain! Rain! Rain! We took dinner at Mr. West's then went to Bald Knob.

April 17, 1939 Just another lonely day. Lawrence took a notion he wants to go home tomorrow.

April 18, 1939 We went to Bald Knob to take a lady to the Dr. Mother came back with us then we went home. It is rather cool and looks like rain.

April 19, 1939 Another rainy day. We stayed at Mothers last night and got up early and went to Mildred's then on to Lance's and washed then back to Russell.

April 20, 1939 Gee I feel tough! I ironed this morning. It is still cool. I don't think the berries will even get ripe.

April 21, 1939 I washed a few pieces today and mopped the floor. The machine is trying to go hey wire Lawrence is working on it.

April 22, 1939 This is a beautiful day after such a cold raney spell. Lola Mae West and I went to a house and got us a bouquet of tulips.

April 23, 1939 Moodys came today and we went to Bald Knob and got a 22lb fish. After dinner we went to Bradford.

April 24, 1939 Dad came over to work on the picture machine. They are building a hamburger joint in front to of the trailer.

April 25, 1939 They finished the eating joint today. Lawrence went to Searcy with Ranney.

April 26, 1939 I went to West's to wash and it came a big rain. Lawrence came after me then took me back. Lawrence went fishing after the rain.

April 27, 1939 Lawrence went to Bald Knob and I ironed, It rained again today.

April 28, 1939 We did more today than we have since we came to Russell. Berries are getting ripe.

May 26, 1939 I worked at Bald Knob today. We both worked there tonight.

May 27, 1939 I went to Bald Knob today and helped Mother and Dad. Lawrence came about two this afternoon to help us.

May 28, 1939 We left Russell at 2:00 a.m. and got home at 5:00 this morning. I really felt bad after being up all night.

May 29, 1939 Alvern and I washed almost all day. Lance and Lawrence wet to Heber Springs we are spending the night with Mother.

May 30, 1939 Mother and Dad Massengill left for Corning. Lance, Evelyn, Lawrence + I went to Batesville and came back by the river and went in.

May 31, 1939 I washed a few pieces and Lawrence made a screen door then we went to Mama's we spent the night at Mildred's tonight.

June 1, 1939 We moved to Heber Springs today. Business is better here than at Russell.

June 2, 1939 Ruth, Gilbert and Cecil came today. I made some new curtains and Lawrence fixed some lights on the trailer.

June 3, 1939 Mother, dad, Mack, Lyn + O.L took dinner with us, Lynn got dad a new truck. We went out home after closing up.

June 4, 1939 Erwin, Elmer, Lawrence and I went to the pond swimming. We went to Batesville then to church at Desha.

June 5, 1939 Lawrence, Erwin, Elmer + Lynn went swimming. I took pap to Banner. Lawrence is fishing tonight. We had a big rain tonight.

June 6, 1939 Mother and I started to wash. Lawrence came in wet + nasty with a big string of fish. we came back to town after noon.

June 7, 1939 We went swimming this morning, Bob Anna, + Jack came this afternoon.

June 8, 1939 We went to Pangburn and Lawrence and Bob went on to Russell. It was late when we got home Bob was so drunk he couldn't walk by himself. L.H. was mad because I was mad and drove too fast.

June 9, 1939 Just another day at Heber Springs. Lawrence made two enlargements. Ruth and I went back to the park.

June 10, 1939 We got a new radio today We had a pretty good day today. Lynn came to spend the night with us and we drove to Pangburn.

June 11, 1939 We slept late then went swimming before noon. I drove the truck back to town.

June 12, 1939 Gee but it is hot today. We got a new freezer and made some pineapple ice cream and it made us sick.

June 13, 1939 Just another dull day the last day of the convention. Lorene, Elvin, Lawrence and I went fishing tonight.

June 16, 1939 We made some cream and Cecil Ritter came by to help us eat it

June 17, 1939 Another Saturday at Heber Springs. We made pretty good today.

June 18, 1939 Mr Pennington drowned today. We went home about 4:00 o'clock and made cream at mama's.

June 19, 1939 I went to Ward's after Juanita and got lost. We went swimming then to the show at Batesville Juanita, Lynn, and I took dinner with Clara Wyatt and Desha.

June 20, 1939 We came back to Heber Springs this morn. Wanda and Lynn came tonight, we made cream Lemonade, and sandwitches

June 21, 1939 Just another hot day! Business is bad today Ruth came and stayed a while.

June 22, 1939 We went to Grandmothers for a chicken supper. We made cream and Lemonade and ate supper outside.

June 23, 1939 Mother, dad, Mack, Lynn, Juanita and Gene's folks all came tonight and stayed untill almost 12:00

June 24, 1939 It has been trying to rain today but we made good. Lynn started back to Calif. Tonight.

June 25, 1939 We took dinner with Mr. + Mrs. Higgs then went to the singing convention at Concord.

June 26, 1939 Lawrence cradled oats today and I canned 15 quarts of cucumbers and 7 of beans then we put out potato slips.

June 27, 1939 We came back to Heber and heard the tax man was in town then we went fishing. We went back out home tonight.

June 28, 1939 I was nurse maid and cook this morning. Lawrence worked in the field. Gee but it really did rain today.

June 29, 1939 I washed today while Lawrence ran around. We went to see Frank and made candy tonight.

June 30, 1939 Charlotte Ketchum came this morning. We made better then we have any week so far.

July 1, 1939 We had a pretty good day today. Gee but it's hot. I wish I was in the land where the Eskimoes grow.

July 2, 1939 We went out home and went to church tonight we go to church so seldom we don't know how to act when we do go.

July 3, 1939 Lawrence + Dad went to find a gang to go to Hot Springs to-morrow. We went to a party at Cleo's. Mary Alice went with us.

July 4, 1939 We went to Hot Springs. L.H. and I went up on the tower. We went to both park's at Little Rock. We enjoyed the trip but were glad to get back home.

July 5, 1939 We came back to Heber this morning. It is still hot here, I would like to go swimming. Gene R. came home with us.

July 6, 1939 We took Doc. Green to Newport to meet his girlfriend and she was drunk when we got there. We stopped at Pridmore's and came back by Bonnie's and stopped.

July 7, 1939 Walter Roach and wife came and we went swimming then we made ice cream. We fixed sandwiches then went to the park. We ate a water mellon then they went home.

July 8, 1939 It was so hot people didn't stir much today. I went to Garretts and washed a few pieces. L.H. went to Quitman to get some developer.

July 9, 1939 We went home this afternoon and ran into a storm. Gee, but I was scared for a while we got into Evelyn's diary and read some.

July 10, 1939 I blistered my back and it really is sore. We went to Mildreds this morn. We intended to go fishing but decided just to swim. All we had for dinner was bread + tomatoes.

July 11, 1939 I washed this morn. and L.H. picked cucumbers. We went to O.L's this afternoon then I canned 12 qts. of pickles.

July 12, 1939 Ted, O.L., L.H. and I went fishing we took things to camp on the river. Ted and I stayed on the island while they stretched the line. When we cooked supper every thing had sand in it. The mosqutoes tried to carry us off.

July 13, 1939 We stayed on the river until nearly non then went to O.L's and cooked the fish. O.L and L.H. went to the creek and Ted and I slept. Gee but it was hot.

July 14, 1939 We came back to Heber early this morning and worked there. I ironed some tonight.

July 15, 1939 We did pretty good today. we made $9.00 in spite of all the heat.

July 16, 1939 We took dinner with Mr. + Mrs. Higgs. They came home with us and stayed the night.

July 17, 1939 Evelyn + Lance came before we got up. We made several pictures of the baby. Higgs came in the afternoon, we went out home to get the truck.

July 18, 1939 I washed at Murrys and fixed to go to Michigan but we didn't get he load and couldn't go. we had to take the truck home. we forgot our key this morn. and had to tear in the back door.

July 19, 1939 I ate dinner with Ruth. she was asleep when I got there. She came home with me and we went to the park.

July 20, 1939 L.H. and Doyle went swimming. Jab and Herbert Foust came while they were gone and played and sang for about 3 hours. Ruth and Amy were here too.

July 21, 1939 We went home this morn. to see if we were going to Hot Springs Sunday. L.W. Evelyn, L.H. and I went to Batesville in papas truck, we got two water melons and ate them at L.W's

July 22, 1939 We made pictures until about 11:30 then Elvin came after he left we went to bed. It was lightening so we got up and went to L.W.'s There wasn't any body home so we tore in the back and went to bed.

July 23, 1939 We started to Heber this morn. and met Dad with a load on their way to Oiltough. We decided to go with them we all took dinner with Mrs. Pridmore. Instead of going to church we drove around after noon.

July 24, 1939 We worked until about noon then went out home to put a new post in the car. L.H. broke the windshield. Ruth L.H. and I spent the night at mother's

July 25, 1939 We came back home abut 9:30 this morn. I ate dinner with Ruth and made me an apron this afternoon. L.H. + I put in a new windshield

July 26, 1939 We went swimming this morn. and hunted mussels I cut my hand on a shell. The Higgs came to have some pictures made. Juanita M., Nola, and Ruth came and stayed a while also Eugene + David.

July 27, 1939 It came up a cloud this morn. and rained the rest of the day. we got a letter from home wanting us to come home tonight and go to Memphis tomorrow. It hadn't even sprinkled out there. (we went to see Polly + Murry tonight)

July 28, 1939 We got up at 1:30 A.M. and got ready to go to Memphis. We went to the zoo first and it rained while we were there. We ate dinner in negro town. I took my first ride in an aeroplane when we were coming back we ran into a storm.

July 29, 1939 We got up early and came home before breakfast so we could work. Lawrence went to bed and slept all morn. and I cleaned the trailer and worked a little and then I tried to sleep a little this afternoon.

July 30, 1939 We got up at 10:30 this morn. I think we were real smart. I don't feel good today and Lawrence wouldn't stay in the trailer with me it hurt my feelings and I cried.

July 31, 1939 Cecil came before we got up and told us Mother Dad were out home. We got up and went out there. Them and all of us kids were there all day. They want us to leave the picture machine at home and go with them.

Aug 1, 1939 I went to Garrett's and washed a little then we made some signs out of white oilcloth and red paint I wonder if L.H. loves me like he should. He would rather be out talking to someone else than with me.

Aug 2, 1939 I ironed most of the day then we moved to the park to get set for the reunion we're expecting a busy time.

Aug. 3, 1939 Whee! What a day. This has been our bigest day so far. Teter and Lance are spending the night.

Aug. 4, 1939 Lance + Teter are still with us WE made a lot more today than we ever have before $62.85. We had to much company to be working so hard.

Aug. 5, 1939 We didn't do so good today. we took the trailer home after we closed we slept in the trailer after we got there.

Aug. 6, 1939 We slept late then Hayden, Edna, Gene, Teter, Lance, Evelyn, L.H. and I went swimming When we came back we went to Gene's and ate watermelon.

Aug. 7, 1939 Lawrence went with papa to Tuckerman and I washed. Elton, Lance, Evelyn and I went to Batesville after noon. Elton and L.H. went to Memphis tonight for supplies.

Aug. 8, 1939 Mother and I made me a dress L.H. and Elton got home at 3:30 A.M. We took the trailer to the water carnival. I was sick when we got there.

Aug. 9, 1939 I spent the day in bed. Every time I start to set up I turn sick. L.H. didn't have many pictures to make.

Aug. 10, 1939 I feel better today. Mildred came and spent the day Evelyn also. We still haven't made anything We took the trailer back home.

Aug. 11, 1939 We went down to the house this morn. then to Mildreds and ate a mellon. L.H. and Dad went to Heber for house paint.

Aug. 12, 1939 L.H. started painting the house today. We went to singing then to Batesville then home with Hayden + Edna tonight.

Aug. 13, 1939 L.H. and Hayden tried to make Edna + I mad all day we spent the night with uncle Oliver and Aunt Stella.

Aug. 14, 1939 We went back to mamas and L.H. painted a little more

Aug. 15, 1939 L.H. worked on the car all day and mother and I put out a big washing. L.H. and I washed the car.

Aug. 16, 1939 Mary Alice, L.H. and I came to the picnic ground in Broidie Creek today a door came off the closet and spilled everything out in the floor. We just had one frame broke.

Aug. 17, 1939 We went to Lake Wood and went swimming we bought our dinner as we came back so we wouldn't have to cook.

Aug. 18, 1939 the picnic started today. Gee such a spot! I'll be surprised if we make expenses here. It rained part of the day.

Aug. 19, 1939 Gosh! Two Thousand People! I'd be surprised if there was two hundred here we are still hoping to make expenses.

Aug. 20, 1939 On account of the rain they are having another day of this torturing picnic. I made all most all of the pictures today

Aug. 21, 1939 Lawrence + Robert left at 1:00 o'clock A.M. to see about a spot at Subiaco. They got back at 10:30. We took Humpy to catch the buses home then we moved to this great city.

Aug. 22, 1939 I washed and cleaned the trailer and L.H. just piddled around as usual. Francis was sick all day.

Aug. 23, 1939 This is the first day of the picnic and we had orders Not to open till 6:00 P.M.

Aug. 24, 1939 We didn't do any thing till night then we made $22.00 The lights were so weak we could hardly make pictures light.

Aug. 25, 1939 We brought the trailer as far as Conway and came on home to stay a few days. The folks were making cream when we got here.

Aug. 26, 1939 L.H. + I went to Batesville and got us some new clothes. We took Duard's folks to the show and spent the night with them.

Aug. 27, 1939 L.H. and Duard spent the day on the creek. Mildred and I went to Ritters for dinner then to Mrs. Kerlins.

Aug. 28, 1939 L.H. painted some on the house and I canned apples. I fixed my juice for jelly.

Aug. 29, 1939 I made a pan of jelly this morn. then went to Evelyns to wash. L.H. went with papa peach peddling.

Aug. 30, 1939 L.H. + papa went to Missouri and got a load of apples It was about mid night when they got back.

Aug. 31, 1939 We left for Mablevale today. We went by Heber S. and saw Moodys. We also went by the station and saw Burk.

Sep. 1, 1939 Gee, but I was sick for a little while this morning I urped all over the floor This is the day before the picnic they are putting up the joints.

Sep. 2, 1939 This is the first day of the picnic. We arn't doing so good but we are close to the snow cone joint and "do we eat them"

Sep. 3, 1939 This is Sunday- the 2nd day of the picnic our compotition got tired of setting and took off. So much the better.

Sep. 4, 1939 This is the 3rd and last day. There are several people here but no body doing much. Every body's sight seeing.

Sep. 5, 1939 We left Mablevale at 3:00 o'clock this morning and didn't sleep a wink last night. We got to Manilla at 2:00 o'clock P.M. Mother, dad, L.H. + I went to the shows.

Sep. 6, 1939 Dad and L.H. went to look for a place for us to make pictures. When they got back we all went to Cardwell to see if we could work there.

Sep. 7, 1939 We moved to Cardwell, Mo. This morning Billie brought me a "cake" I had quite a job cleaning the trailer after moving.

Sep. 8, 1939 I think I will like Mo all right we are going to do pretty good here. We look for a good day tomorrow.

Sep. 9, 1939 Gee, but we are tired we made $41.00 today and my feet are about to kill me.

Sep. 10, 1939 We went to Manilla this morning to see if we made more than mother + dad. we did.

Sep. 11, 1939 Every week day is just about the same most everybody is picking cotton.

Sep. 16, 1939 Another big day- we made $50.20

Dec 7, 1939 I have neglected the diary for a long time but we have accomplished quite a bit during that time. we left Missouri and went to hunt a location. We spent the first night at manilla. We got up early the next morning and mother + dad went as far as Memphis with us and got the typer. We went on to cotton plant that night but there was a mug joint there. We spent the night with Audrey then went to Clarendon the next day. One week was enough of that so we came on home we fixed the trailer up while we were there. It cost us around $30.00. while we were there I started urping everyday (sign of pregnancy) "yep that's the trouble" the Dr. said so. We were out home two weeks then came to Heber Springs we moved our in the crib last week then decided to come back here 'till after xmas. Goody, that's just two more weeks. We have been out there enough to make about 42 coops. And expected to make lots more after x mas.

Feb 10, 1941 It was snowing when we woke up. We went to Banner and stopped at Murrys. We are spending the night at mamas. We started me a smock but didn't finish it. Papas went after his car. It is a '28 chevrolet.

Feb. 11, 1940 L.H., Mack, Mother + I started for a little spin in Dads "new car" it was so muddy we could hardly get up the lane then something happened to the thing and we had to turn and go back.

Feb. 12, 1940 L.H. + I were ripping strips and I failed to catch one. The saw caught it and slung it against his head, I thought it had killed him I hope I'm never so badly scared again.

Feb 13, 1940 It was snowing to beat sixty when we got up and kept it up most of the day. Duard came to work but it was too bad. Dad, Duard, L.H. + I played 3 games of pitch.

Feb. 14, 1940 Mother, Dad, L.H. + I rabbit hunted all morning. We just got two. I baked a cake for dinner.

Feb. 15, 1940 L.H. and I ripped elm into rod strips today. We got done in time to go to the play at the school house.

Feb. 16, 1940 I ironed and L.H. and Dad turned rounds. I helped cut the rounds in lengths. I feel like I might be about to miscarry.

Feb. 17, 1940 Another rainy day. L.H. has the car under the shed making a truck out of it. John + Alfred came to play pitch.

Feb. 18, 1940 It has snowed all day. We stayed home 'till about 3:30 and then went to mothers and spent the night. Grandma was there.

Feb. 19, 1949 It snowed again all day. Too bad to do any thing but eat we had fried chicken for dinner. My bed got on fire and burned a hole in the spread.

Feb. 20, 1949 (here)

Feb. 21, 1949 We went to papas this eve. To get our pig + chickens they gave us + decided to sty 'till morn.

Feb. 22, 1940 Jordons house burned this morn. at 2:30 we got there too late to help save any thing. Our pig got out of the car and ran off I scrubed while L.H. went back to hunt it.

March 3, 1940 Evelyn and Warren ate dinner with us. L.H. made Parrish a watch chain. we took it to him this eve. and came back by Slick's + Freda's. they surely have a sweet baby.

March 4, 1940 I helped L.H. rip some squares till noon then we prooned grapes. the rest of the day. I got so cold about the middle of the evening I just shivered till we quit.

March 6, 1940 This is a beautiful day. L.H. is working on the coops + I raked off my yard and got my wash wood and water to start my washing early tomorrow (I'll bet it rains) (we got the cow today)

March 7, 1940 Ray Curtis nearly bled to death. Dad took him to the Dr. I am making a dress. L.H. is working on L.W.'s truck it has been snowing about all day.

March 8, 1940 I finished my dress and L.H. finished the old truck and worked on the coops after noon. Mother + Dad went to Bald Knob.

March 9, 1940 I am still sick with a cold but I washed + scrubed the kitchen today. L.H. was tired + I was sick so we took our bath and went to bed early.

March 10, 1949 I was ministrating when I woke up this morning and no body knew what to do about it. Mother + L.H. were worried and L.H went after Mom they gave me orders to stay in bed. Uncle Lee + A. Annie came also Alfred + John. I coughed hard all night last night + couldn't sleep.

March 11, 1940 Mother got a telegram from North Carolina that her brother couldn't live long. She and Dad left just after noon to see him. Duard is going to help L.H. finish this bunch of coops. Mother made me promise to stay in bed all week.

March 12, 1940 Poor L.H. has to cook his own breakfast and work hard all day. Mom spent the day with us. It has been rainy + foggy all day.

March 13, 1940 We sold 50 coops today. L.H. went to Millers after hickery and had a breakdown. It was after 10 p.m. when he got back "was I mad" and how.

March 14, 1940 L.H. + Duard tried to turn rounds but the hickery was too bad. Mom + Mack are spending the night with us.

March 15, 1940 I went to see Dr. Matthews. He said "Stay in bed 10 or 15 more days "Gee but thats a long time." L.H. got a hair cut. Believe it or not.

March 16, 1940 L.H. brought me to Mom's to stay 'till Mother comes home or till I can be up. Verda and the kids stayed until after noon L.H. and Papa went to town and traded papas car for a '35 international.

March 17, 1940 L.H. + papa went to uncle Ottie's and Mark went to Sunday S. Mother + I spent most of the day by our selves.

March 18, 1940 I spent most of the day embroidering and L.H. went to look for some elm. Mrs. Morgan came this morn.

The diary entries have not been altered and are reproduced as originally written.

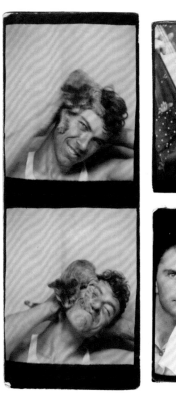
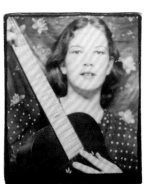
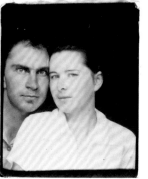